YISHAN LI is an internationally renowned professional comic and manga artist based in Shanghai. A best-selling author, she has sold over 250,000 copies of her books worldwide. Yishan has been drawing manga since 1998 when she was in high school.

Visit her website: www.liyishan.com

Other books by Yishan Li:

Also in the Draw 30 Series:

Draw 30
Manga
in easy steps

Yishan Li

Search Press

About this book

Each of these 30 manga boys and girls can be drawn in eight simple steps: the first shape is drawn in blue, then new shapes are added in pink, dark blue and orange. Black lines are used for the final drawing, then the completed image is fully coloured.

Just grab some paper (normal copy paper will do), a pencil (preferably 2B) and an eraser. To finish your drawings you might want to use a black waterproof gel pen, along with whatever colouring method you like!

Remember: your characters should come with an interesting backstory and a defined personality. Having a clear picture in your mind before you start to draw is the best way to make them authentic and engaging!

Yishan x

The contents

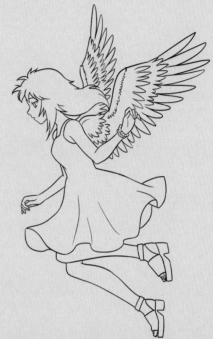

The Drawings

1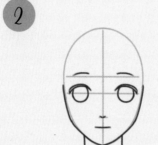

2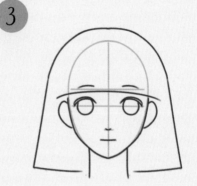

3

4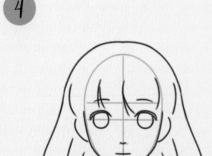

5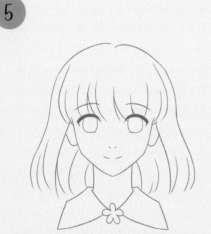

4

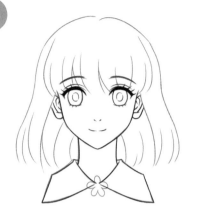

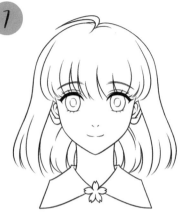

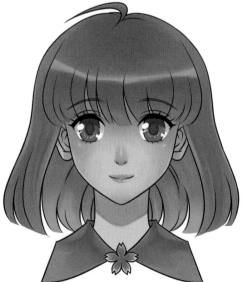

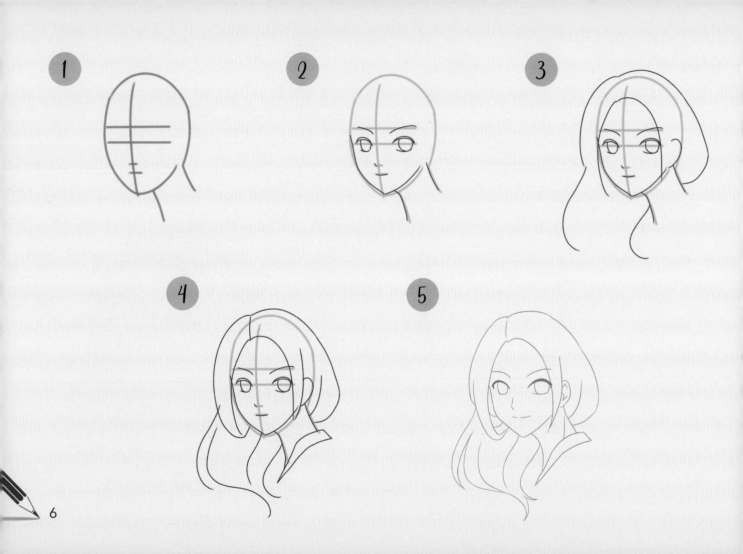

6

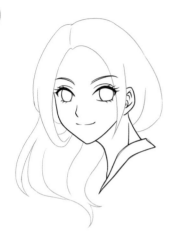

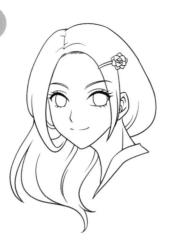

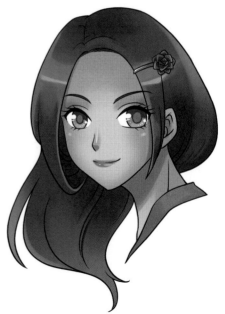

7

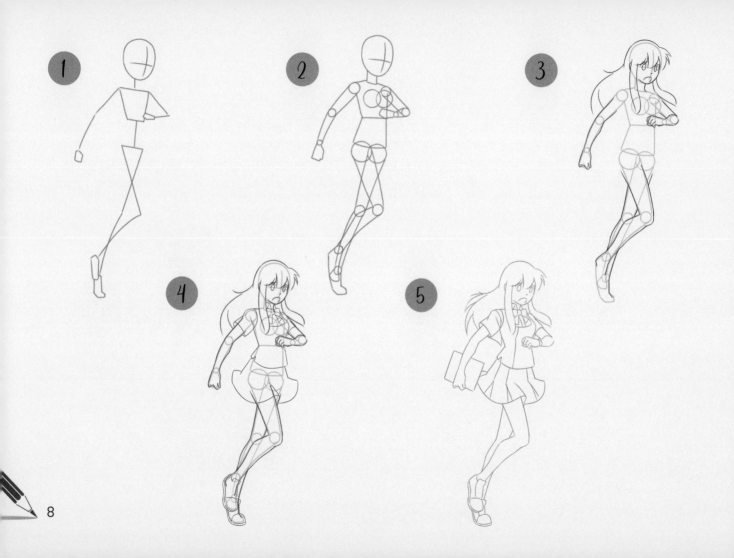

8

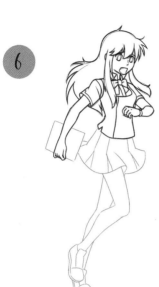

6

7

9

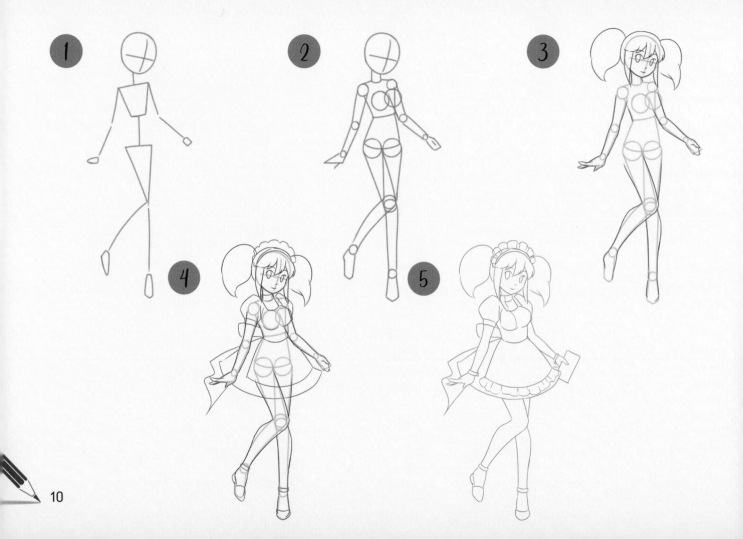

10

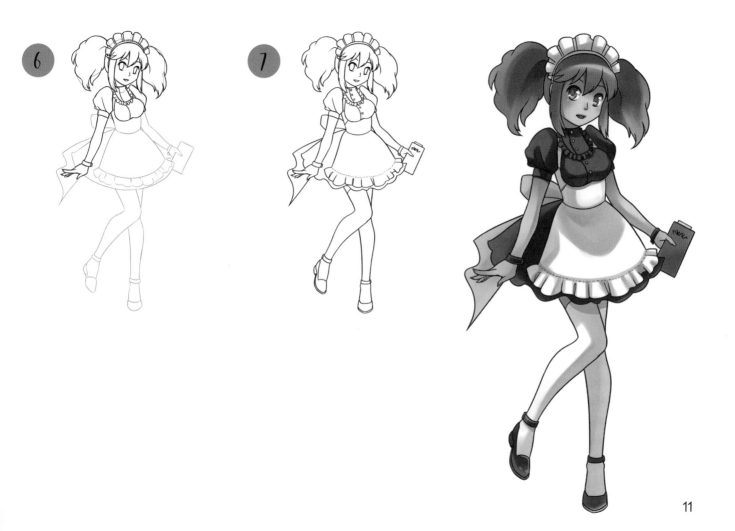

11

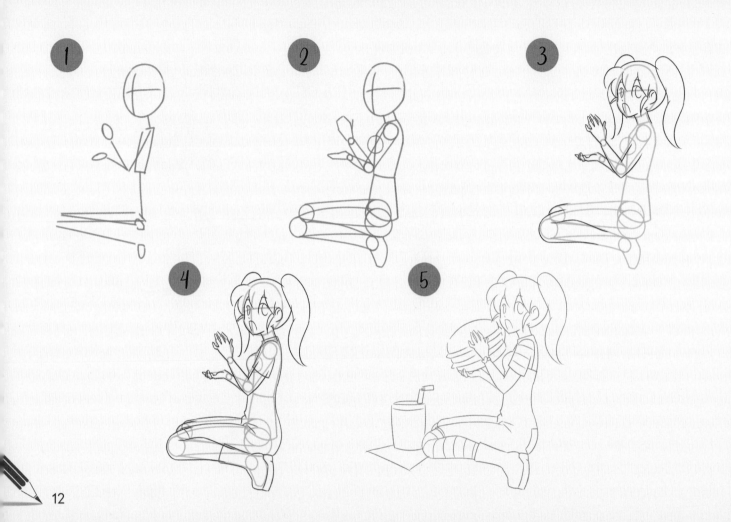

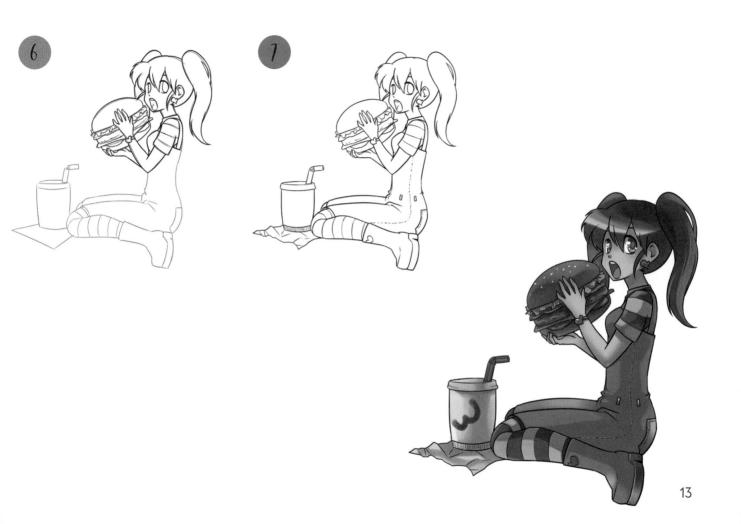

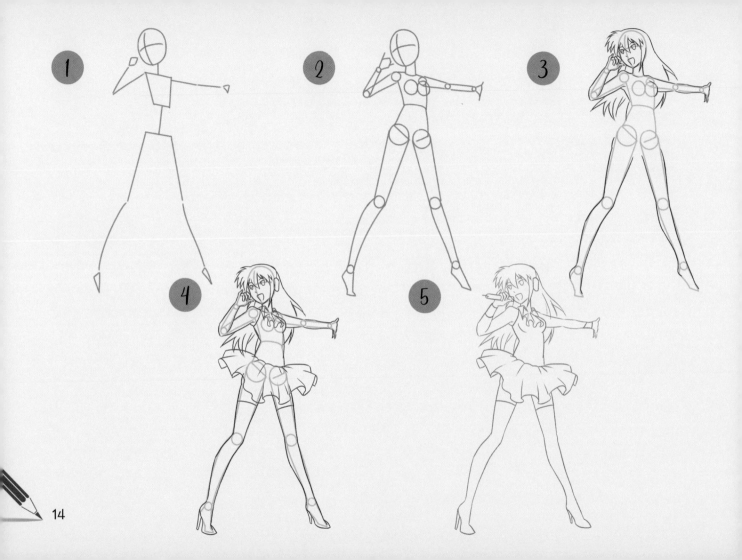

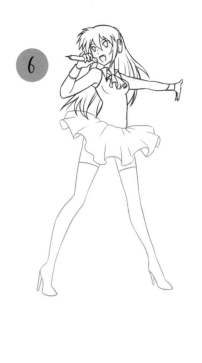

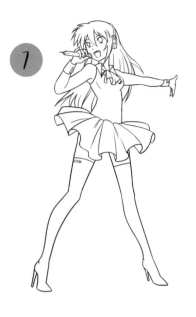

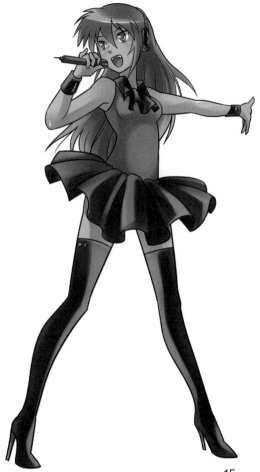

15

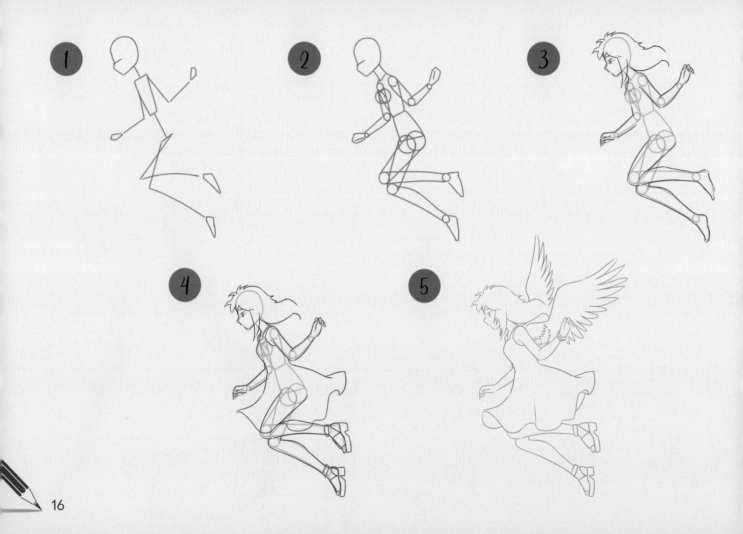

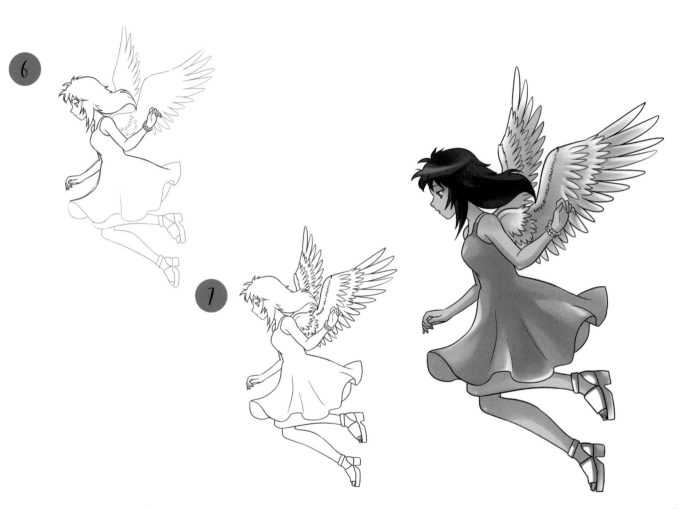

6

7

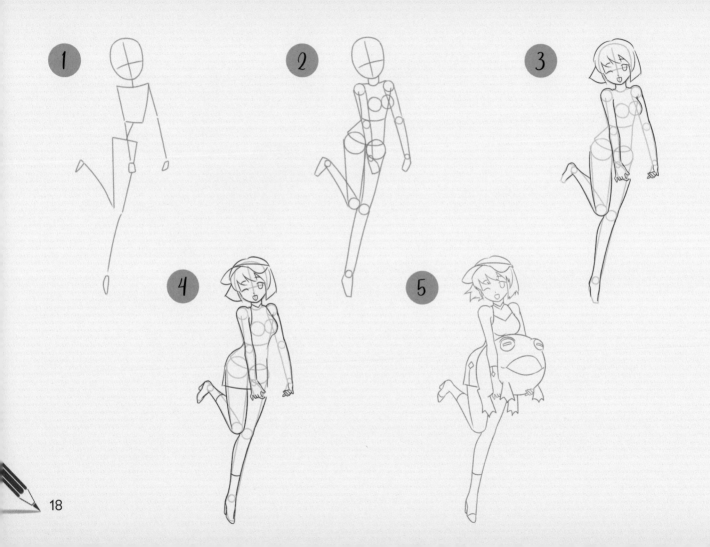

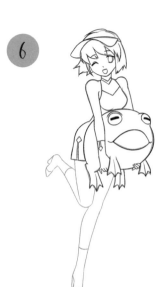

6

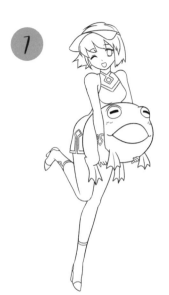

7

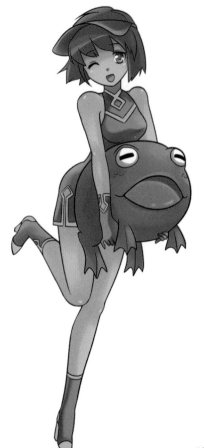

19

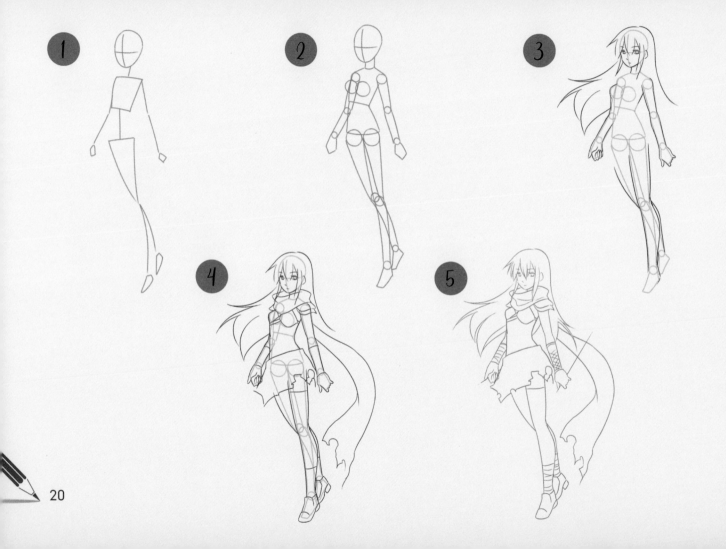

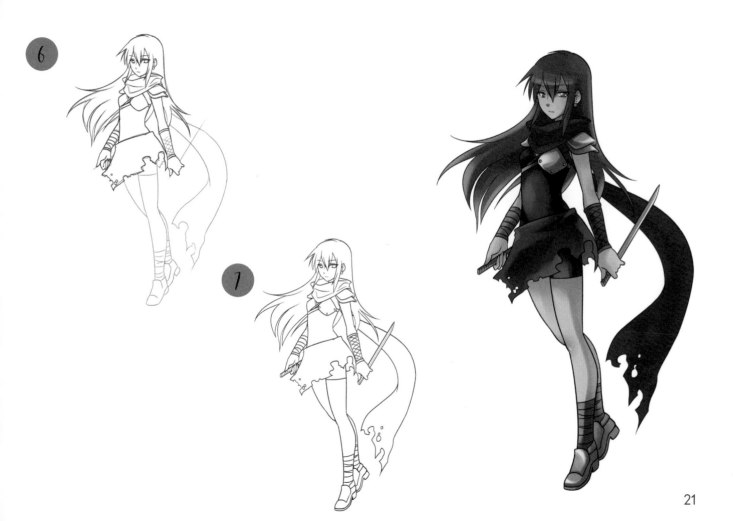

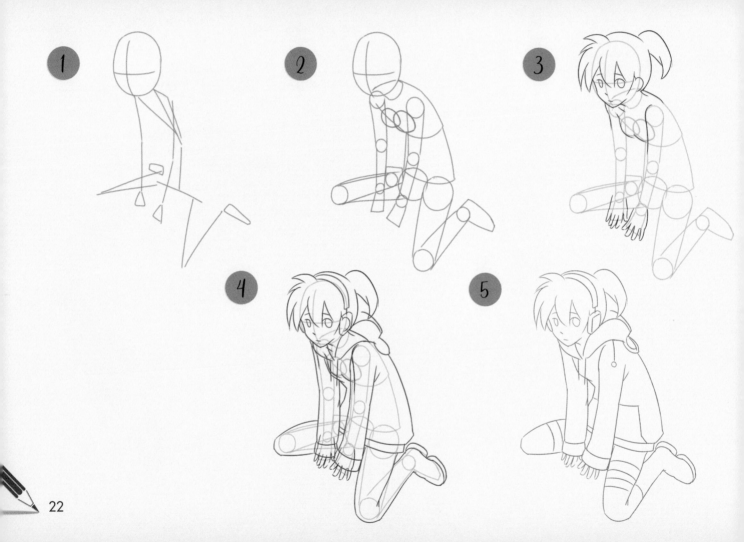

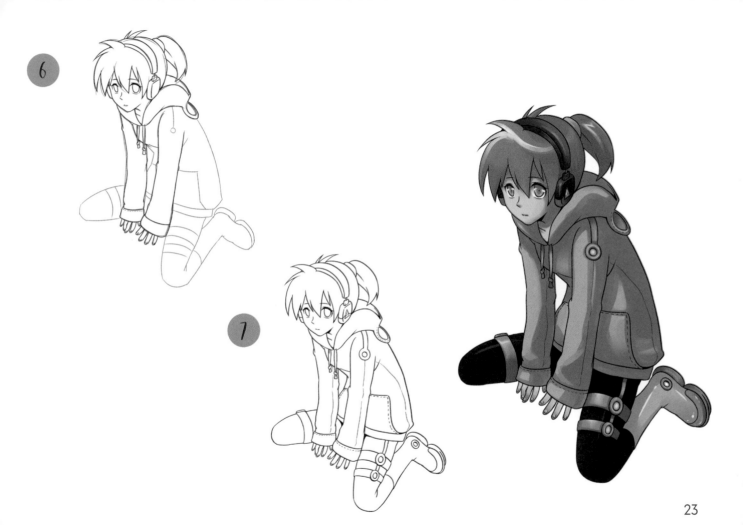

23

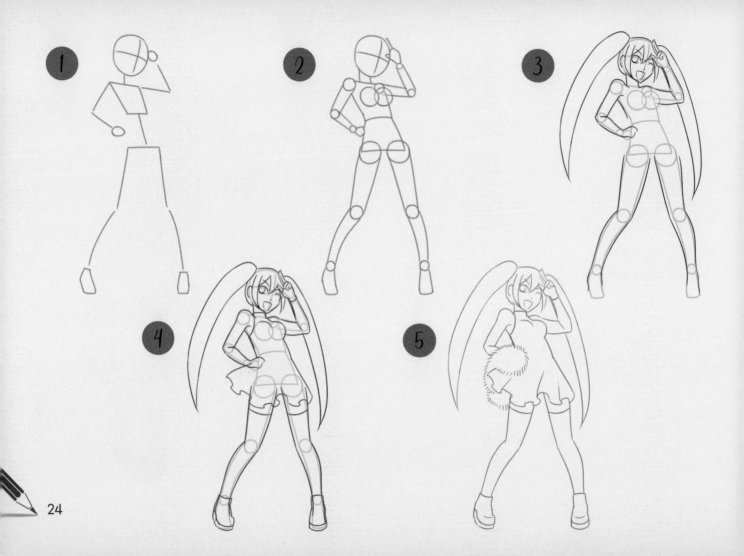

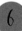

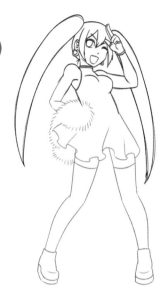

7

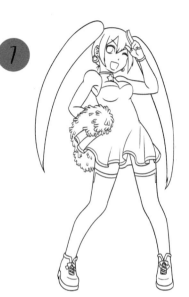

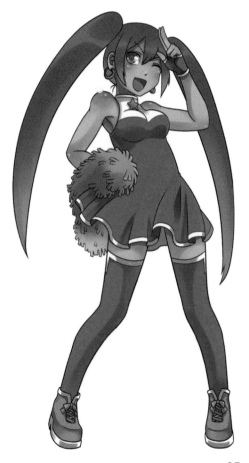

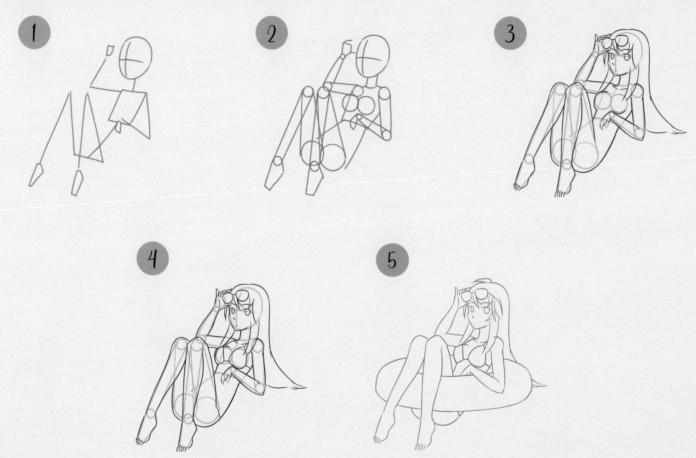

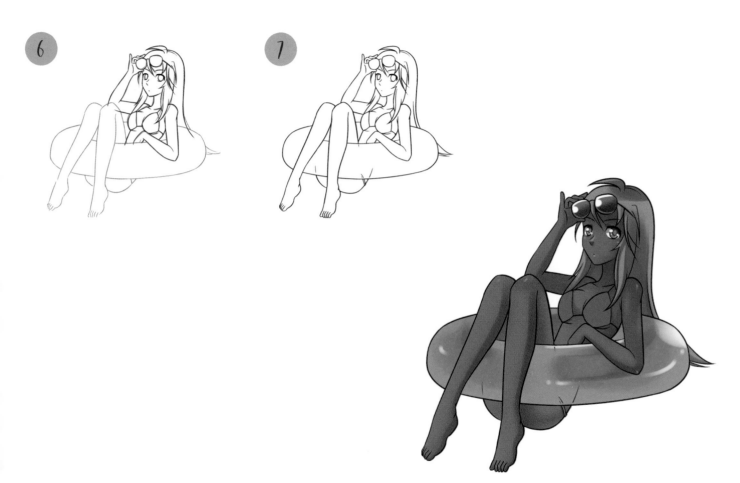

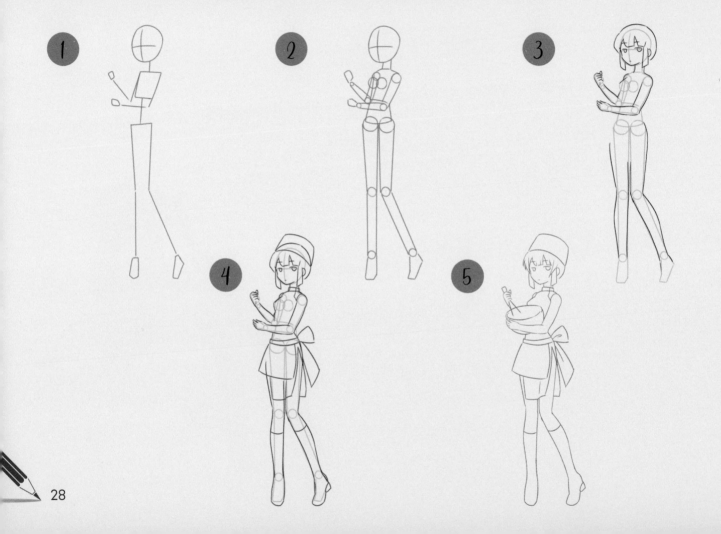

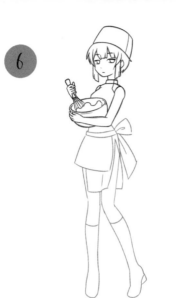

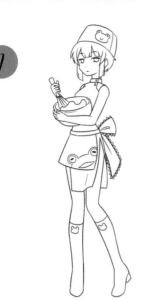

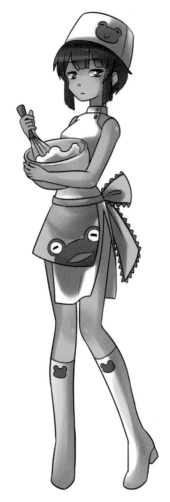

29

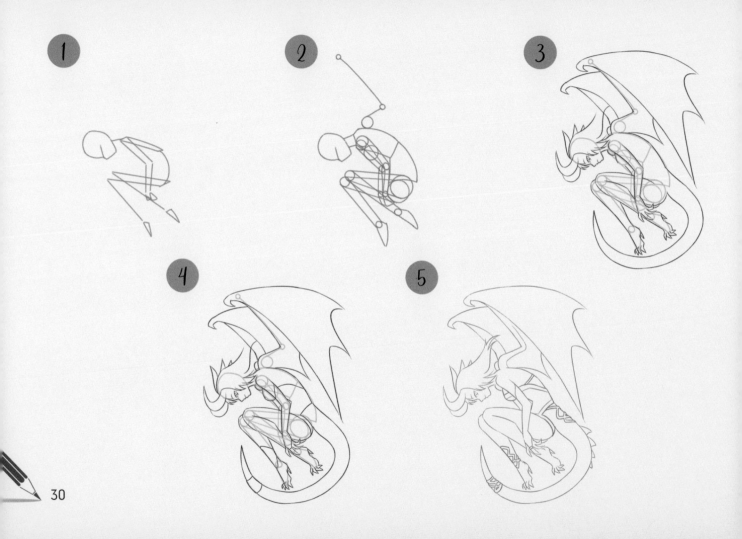

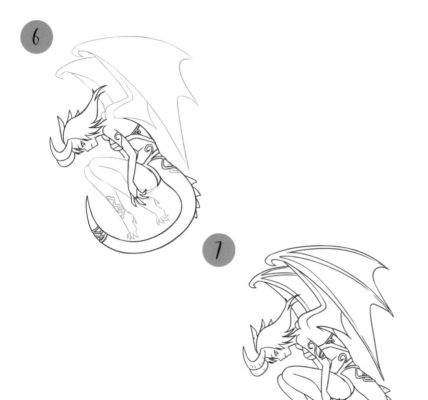

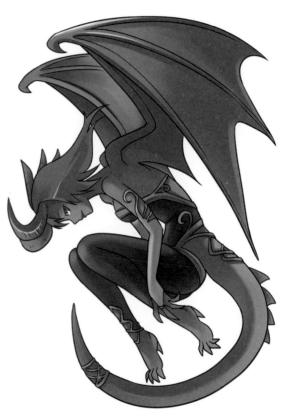

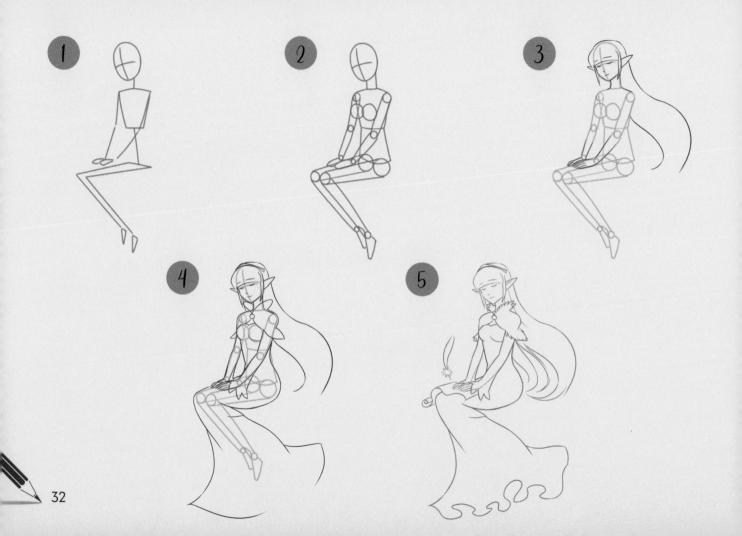

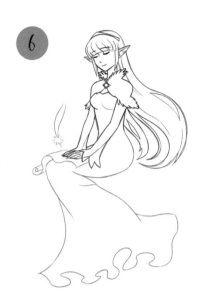

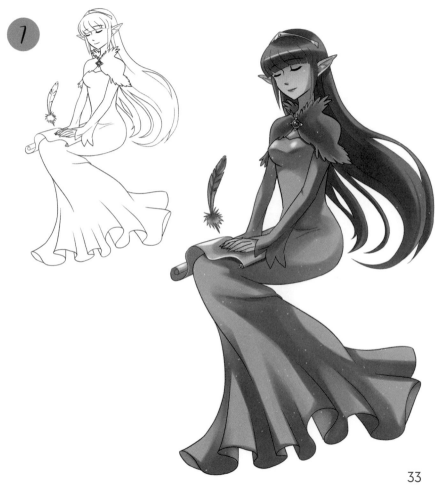

33

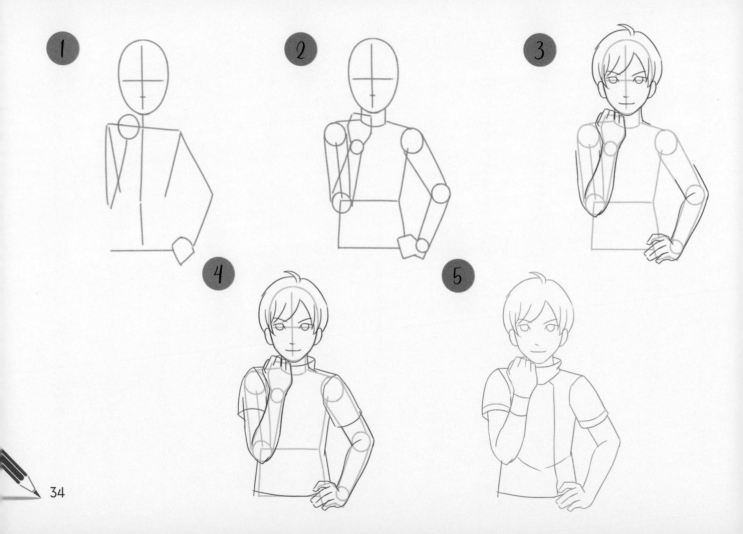

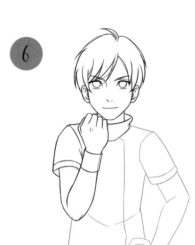

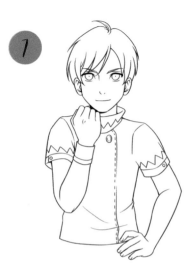

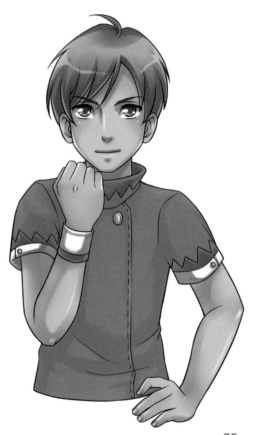

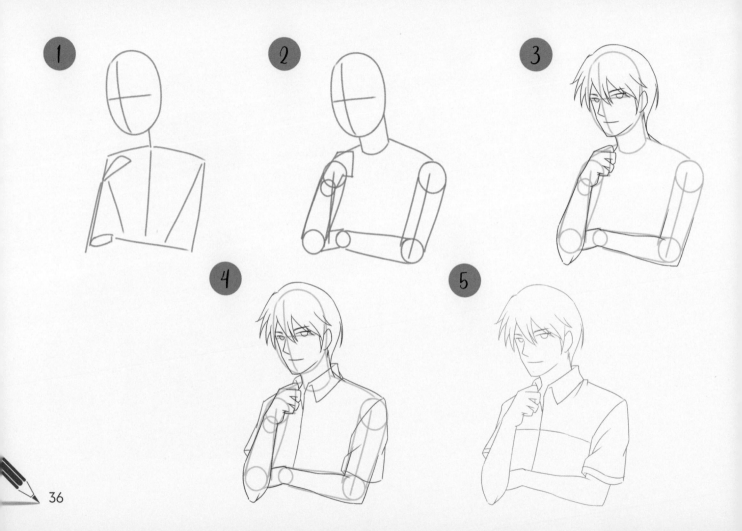

6

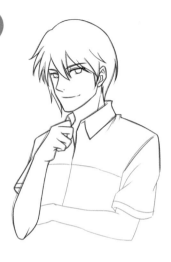

7

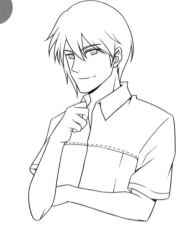

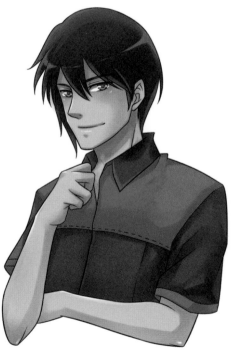

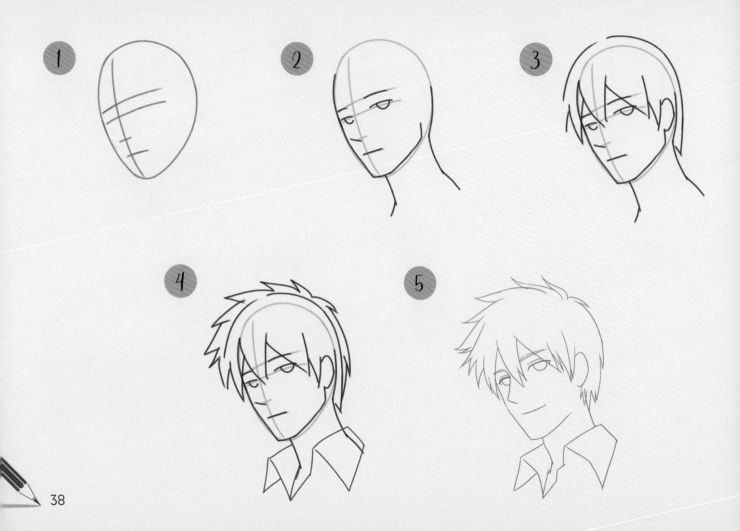

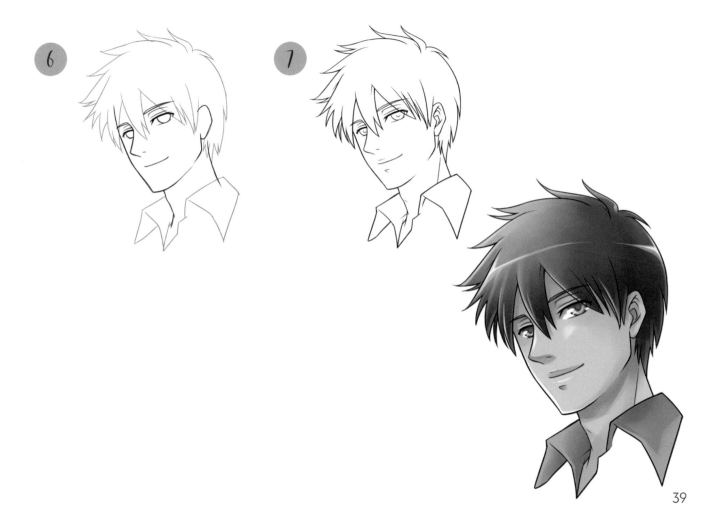

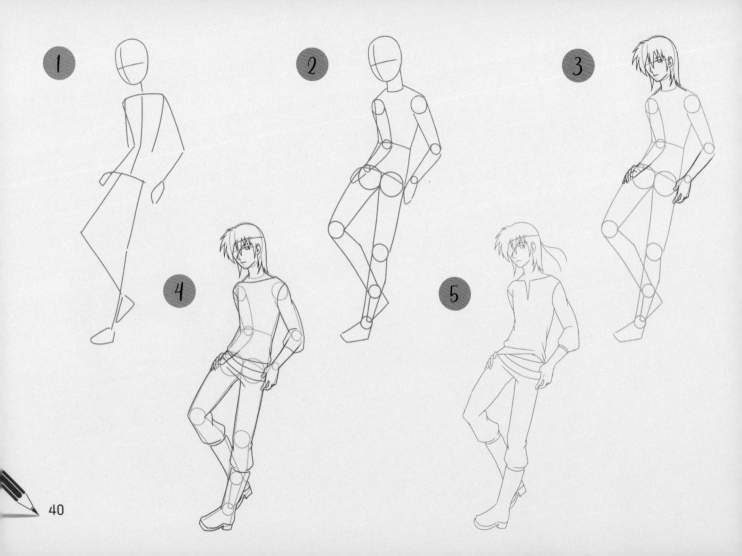

6

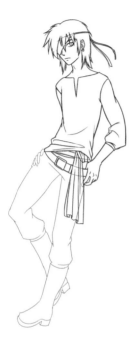

7

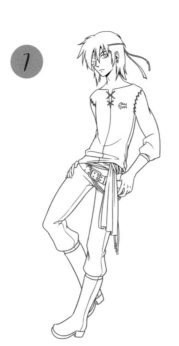

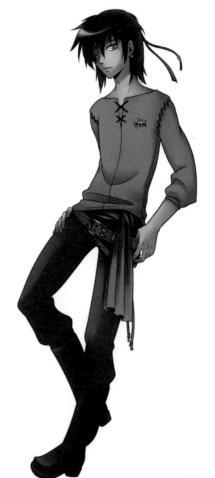

41

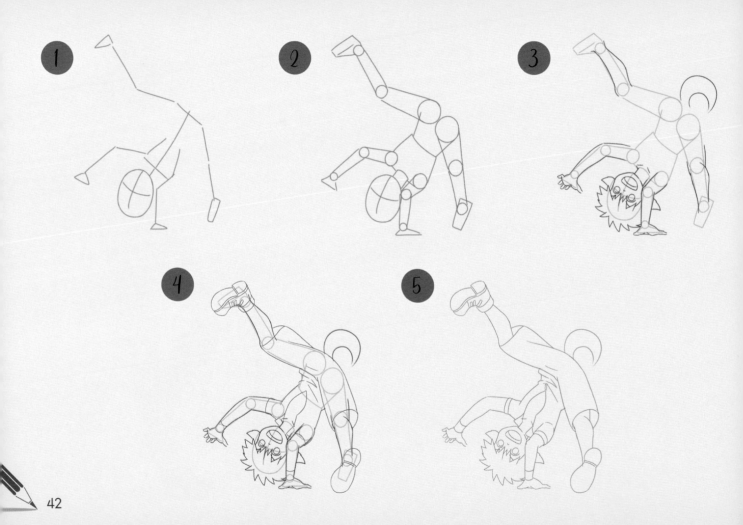

42

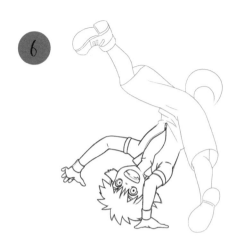

6

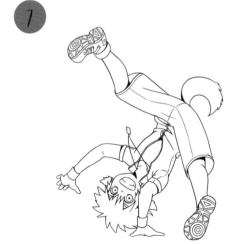

7

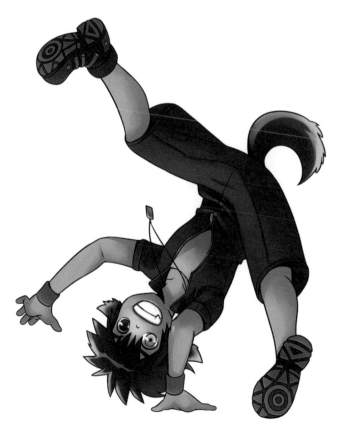

43

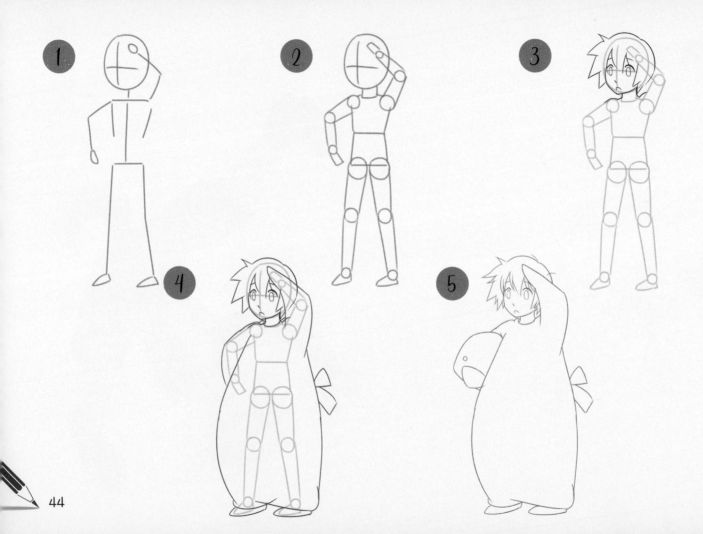

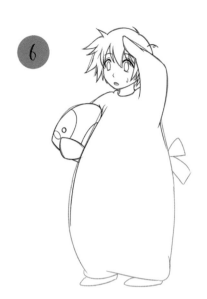

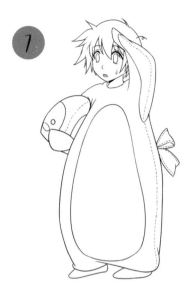

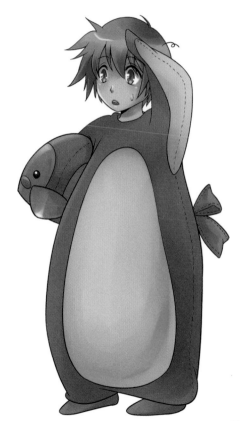

45

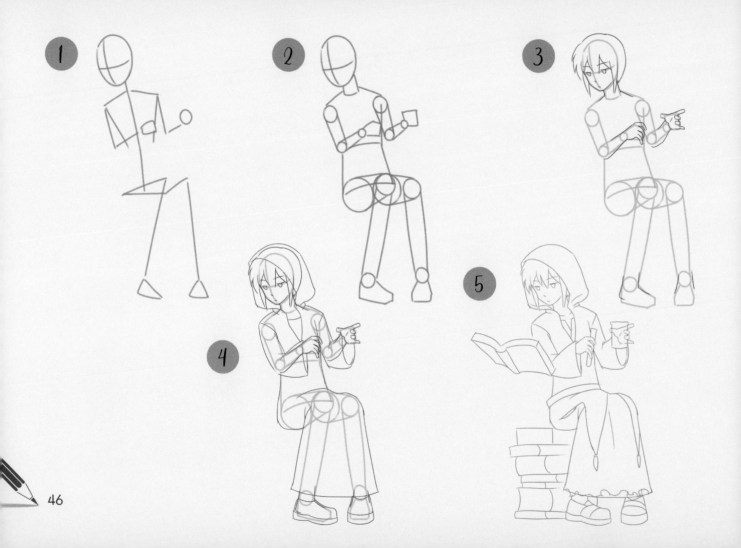

46

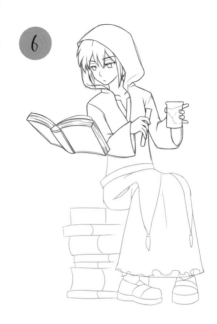

6

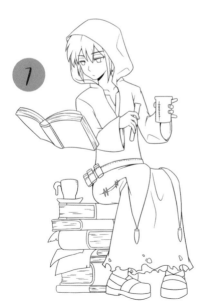

7

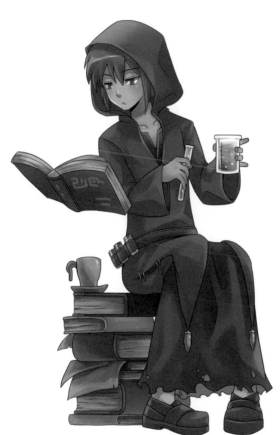

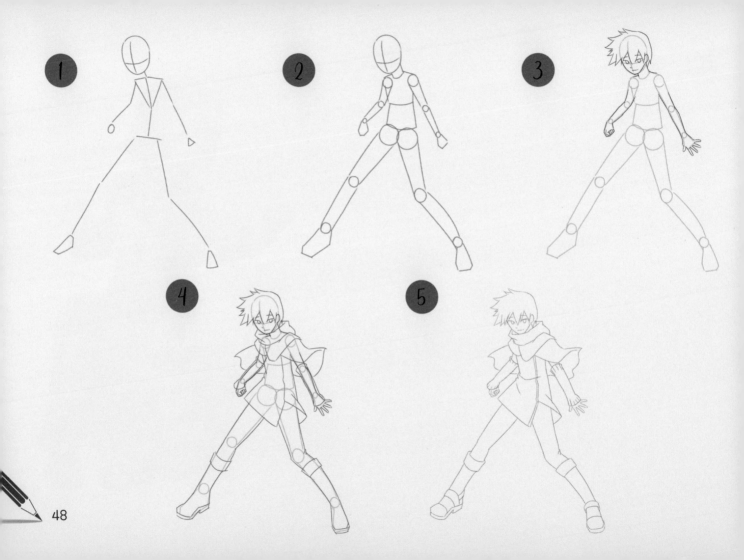

48

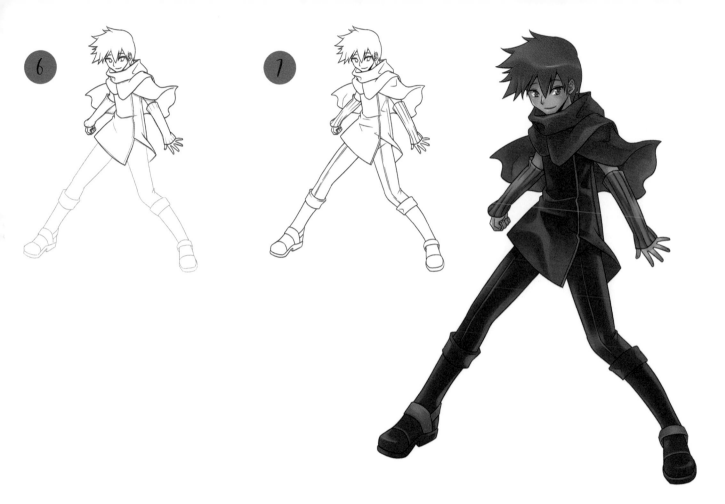

49

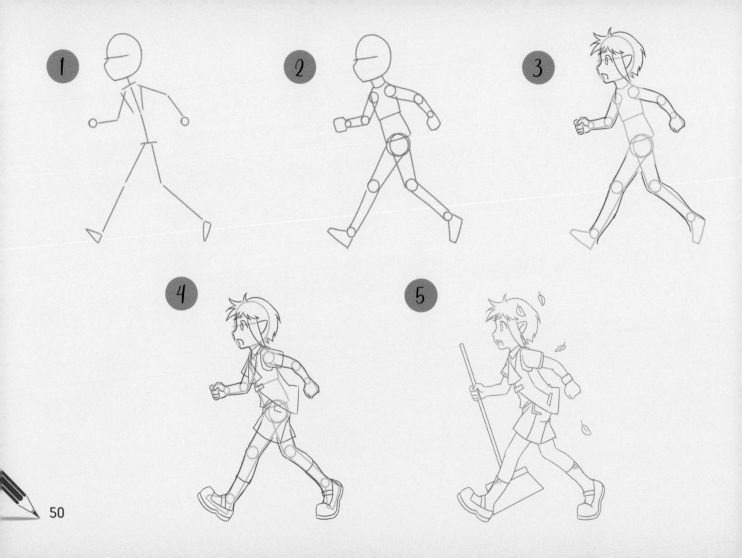

50

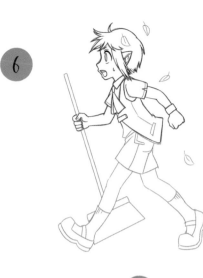

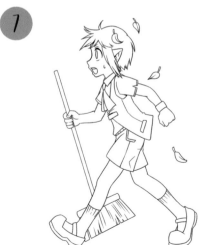

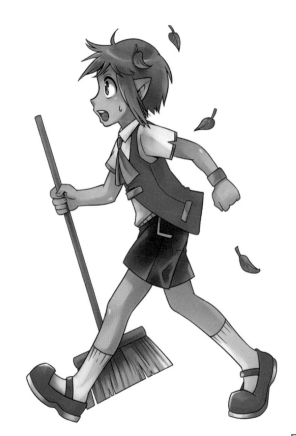

51

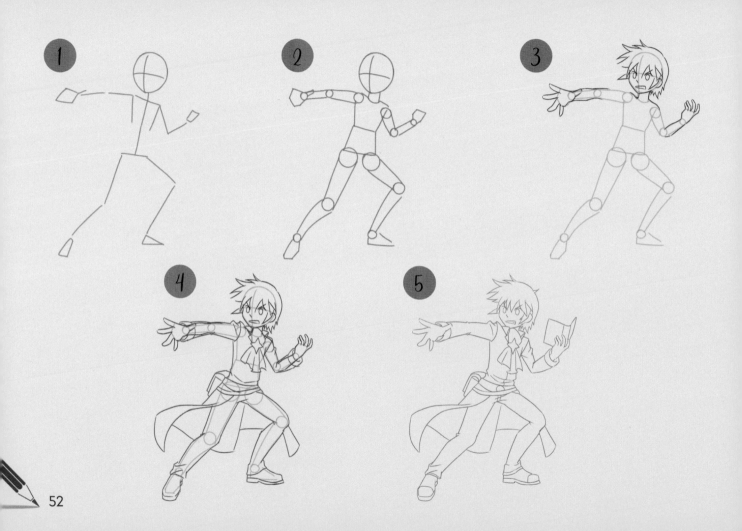

52

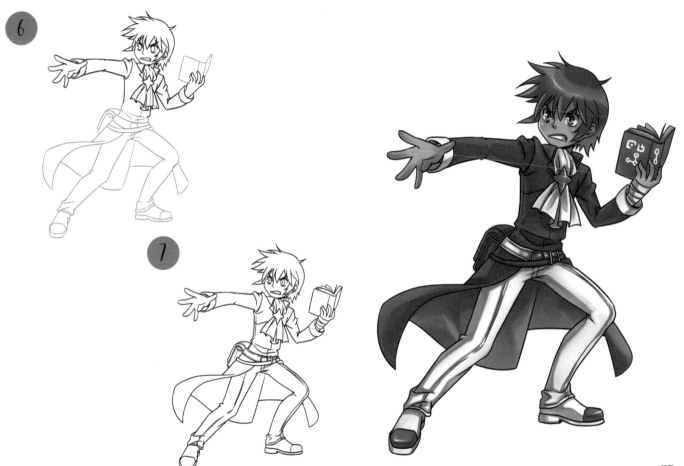

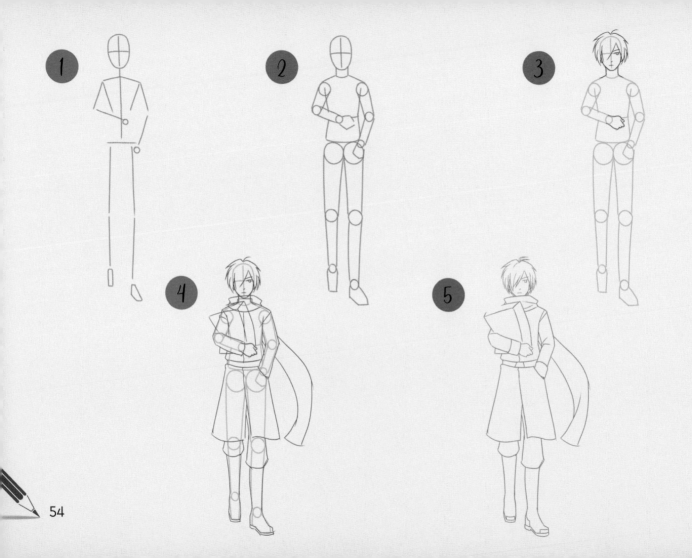

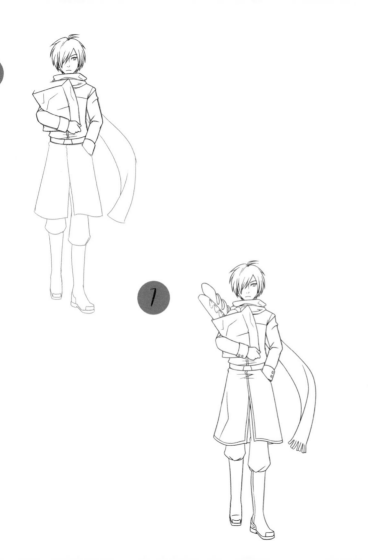

6

7

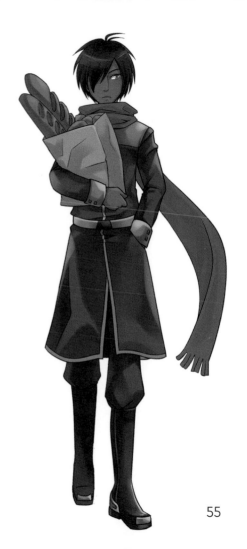

55

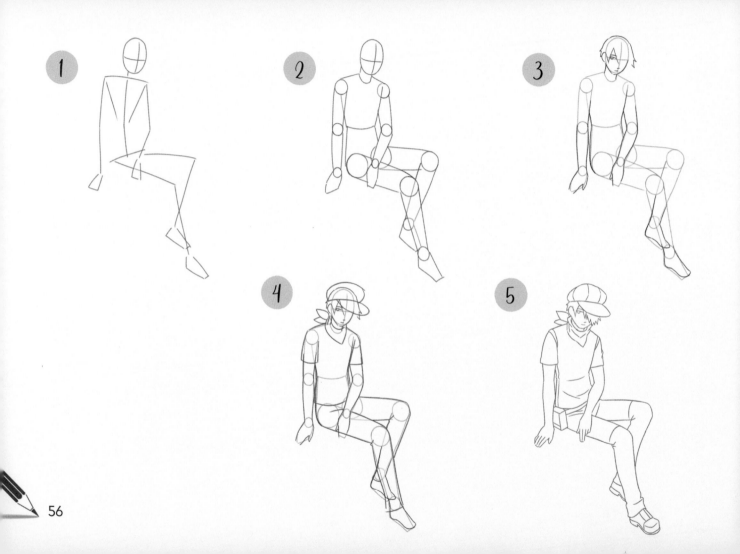

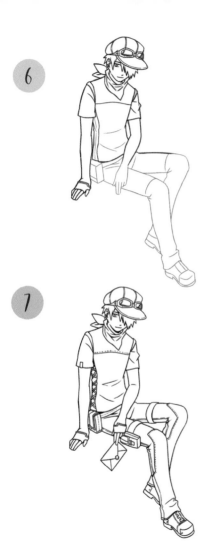

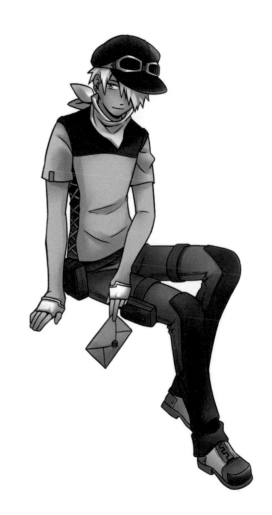

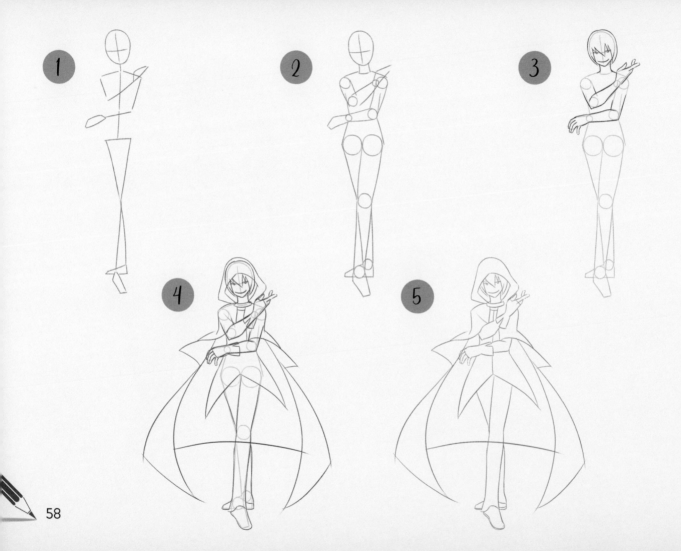

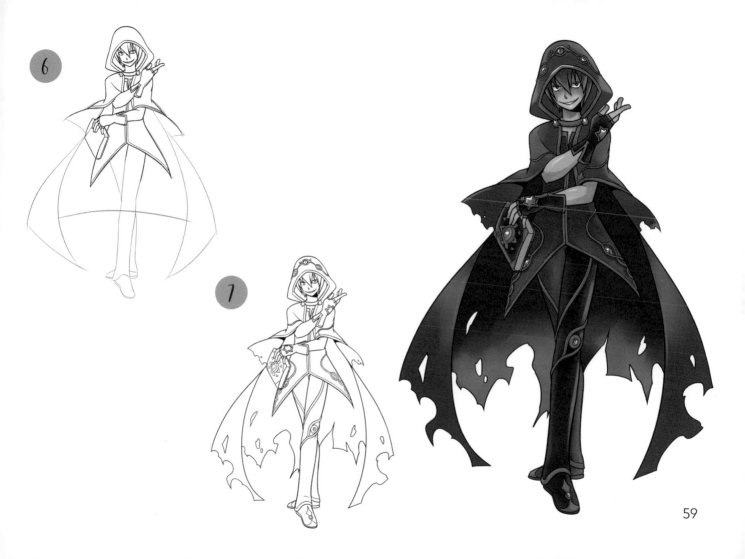

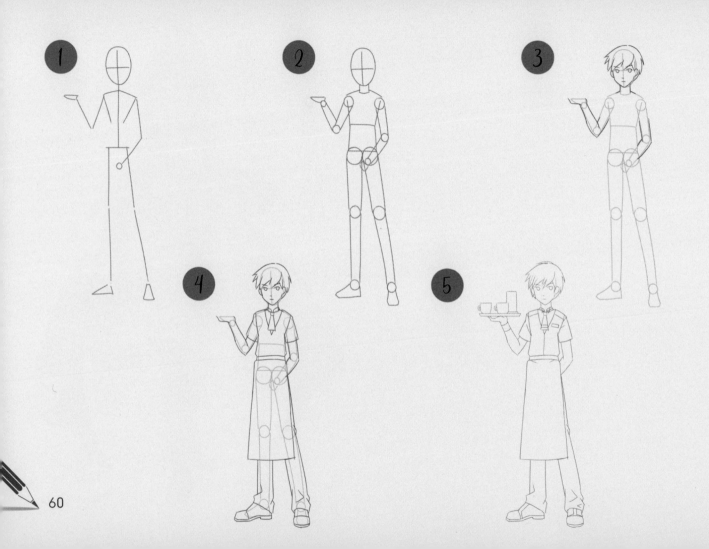

6

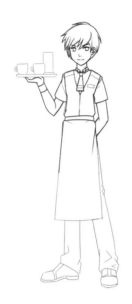

7

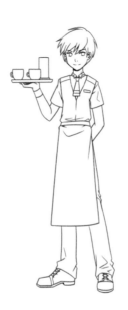

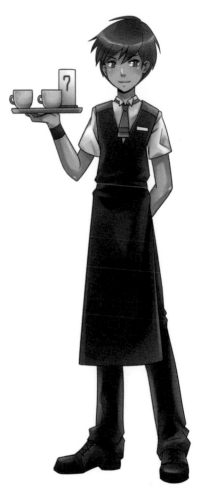

61

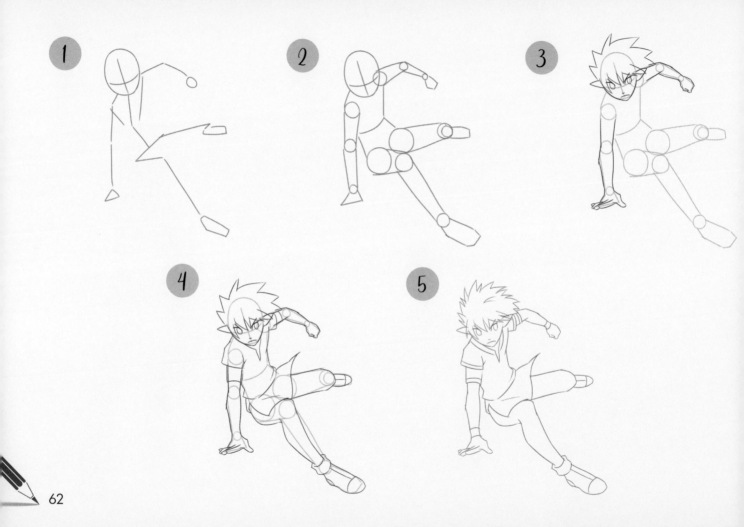

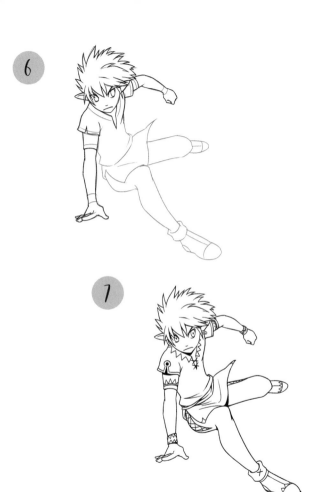

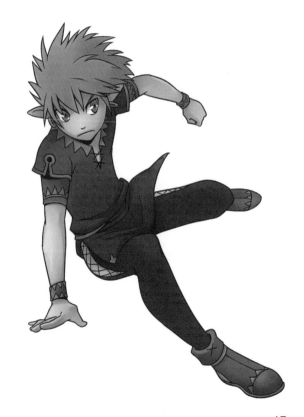

63

First published in 2023

This book uses material previously published in
How to Draw Manga Boys and *How to Draw Manga Girls*, 2015

Search Press Limited
Wellwood, North Farm Road,
Tunbridge Wells, Kent TN2 3DR

ISBN: 978-1-80092-185-6
ebook ISBN: 978-1-80093-171-8

For further ideas and inspiration and to join our free online
community, visit www.bookmarkedhub.com

Dedication

For Patrick.

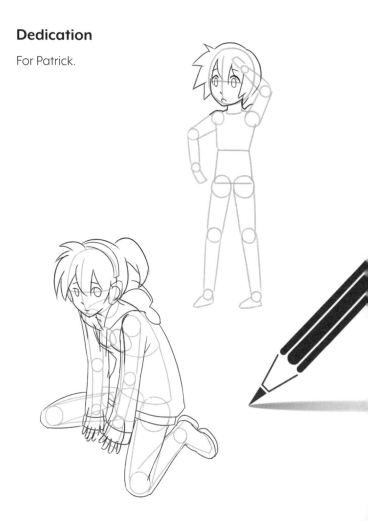